WHAT REALLY MAKES AMERICA GREAT

WHAT REALLY
MAKES AMERICA
GREAT

ILLUSTRATED BY THE ARTISTS OF
CREATIVE ★ ACTION ★ NETWORK

FOREWORD BY STEVEN HELLER

Andrews McMeel
PUBLISHING®

Andrews McMeel Publishing
a division of Andrews McMeel Universal
1130 Walnut Street, Kansas City, Missouri 64106

www.andrewsmcmeel.com
www.creativeaction.network

18 19 20 21 22 TEN 10 9 8 7 6 5 4 3 2 1

ISBN: 978-1-4494-9634-0

Library of Congress Control Number: 2018946743

Editor: Jean Z. Lucas
Designer: Aaron Perry-Zucker
Art Director: Arnie Fenner
Production Manager: Tamara Haus
Production Editor: Dave Shaw

"One of the things that struck me as odd about this election . . .
and maybe I just missed it . . . was nobody asked Donald Trump,
'What makes America great?'"

—*Jon Stewart, November 16, 2016*

CONTENTS

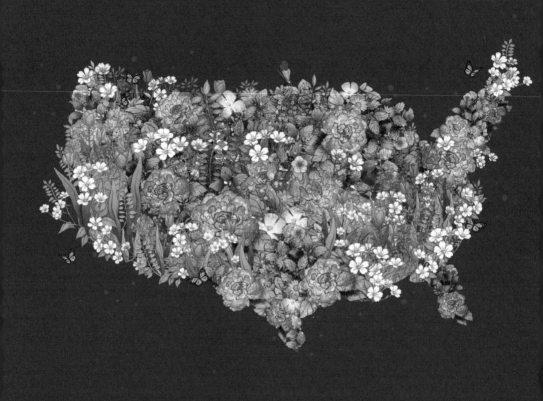

FREEDOM AND DIVERSITY
MAKE AMERICA GREAT

FOREWORD

What is GREAT? The word means (and signifies): ". . . of ability, quality, or eminence considerably above the normal or average." In other words, great is a person, place, or thing that rises beyond the trite—that excels in the face of mediocrity and transcends the timeworn and the outworn. And the following preamble represents that very transcendence: ". . . in order to form a more perfect Union, establish Justice, insure domestic Tranquility, provide for the common Defense, promote the General Welfare, and secure the Blessings of Liberty to Ourselves and our Posterity, do ordain and establish this Constitution for the United States of America."

To understand the greatness of America, it is not necessary to go further than the Constitution of the United States and the Bill of Rights. No other nation has this binding document. The exercise of these tenets and the essence of these words should be clear to everyone. America is great because its greatness is built into our collective faith in and practice of common values. As long as "the blessings of liberty" are respected, there can be no challenge to the democracy on which it stands.

Yet these fundamental blessings are currently being questioned. Nothing can be a more dangerous challenge than maintaining the power of the Constitution. These posters, which come from all over the nation, from many hearts and minds, layered with many sentiments, are not what will make American great again. Posters are just artifacts, and these posters will do little to ensure freedom and liberty if forces more powerful than their makers are seeking to take it away. But this artwork will remind everyone what greatness is and what it takes to keep it that way.

Steven Heller
Art Director, Author, and Editor
New York, NY

Facing page: Art by Julia Yellow

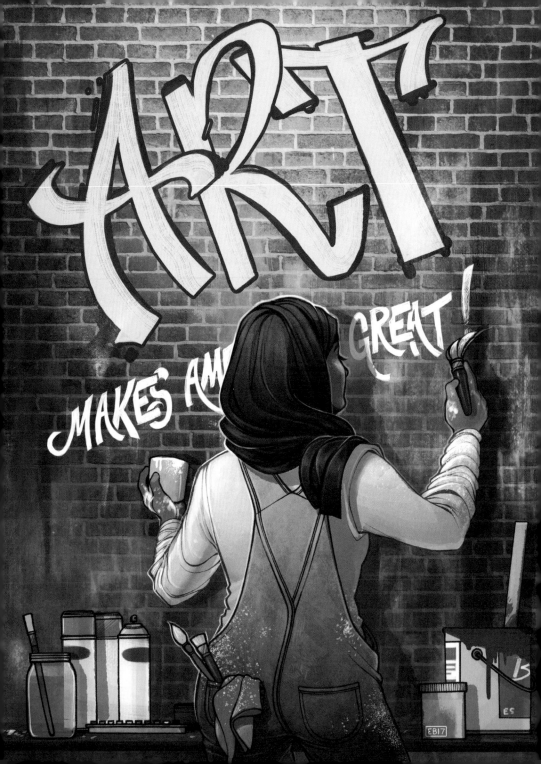

INTRODUCTION

America is great.

And there is no shortage of reasons why. That's why we were so struck by Jon Stewart's question right after the election: What makes America great? For all the rhetoric during the campaign, no one had answered what, specifically, makes America great, or how, exactly, we'll know when it's great again.

So immediately after the election, we at Creative Action Network, a global community of artists and designers making art with purpose, posed that very question to our artists to see how they might illustrate America's greatness.

Starting on Inauguration Day, our goal was to get 100 posters from 100 artists for the first 100 days of the new administration. But not surprisingly, there were far more than 100 artists with something to say, so we kept the campaign going beyond the first 100 days, and continue to receive new submissions as of this writing. The designs we received are as diverse in visual style and execution as they are in subject matter, and the artists behind them represent the incredible diversity and talent that make America great. To see the full collection of posters or contribute your own, **visit www.creativeaction.network**.

The collection of posters has been seen by millions online, hang on walls in homes nationwide, and are archived in the Library of Congress for future generations to learn about this time in our history. Proceeds from the sale of this book, as well as all the What Makes America Great posters and apparel available online, support Dream Corps, a social justice accelerator founded by Van Jones that advances economic, environmental, and criminal justice solutions. Their work is needed now more than ever.

From the beginning, America has been a collective effort to be greater, to be "more perfect." We hope that these posters serve as a reminder of just how great we really are, and why. Thank you to all the artists who have contributed their time and talents to showcase the things that really make America great, and to all the activists, marchers, and community organizers who make it even greater every day.

Aaron Perry-Zucker and Max Slavkin
Cofounders, Creative Action Network
San Francisco, California

Facing page: Art by Elizabeth Beals

AGRICULTURE

by Jordan Johnson

Farming has been a massive part of the growth and sustenance of America since its birth, and it continues to be a very important and evolving industry. I grew up on a produce farm myself! Although I can say with authority that painting is a little easier than picking rocks out of a field or spreading straw, I've met some of my favorite people and have learned some very important life skills thanks to my relationship with agriculture.

AGRICULTURE

Makes America Great

BASEBALL

by Brandon Kish

Baseball is America's pastime and brings us together as Americans every summer.

BASEBALL

MAKES AMERICA GREAT

BELIEF IN THE POSSIBILITIES

by Jennifer Bloomer

I believe at its best this is a country of possibility. It is a country where creativity and innovation are valued. This piece was created as a hope and a prayer that that innovation and creativity will be used to come together, recognizing our differences as well as our common humanity.

BELIEF IN THE POSSIBILITIES *makes America Great*

BLACK HISTORY

by Nikkolas Smith

I wanted this piece to be a reminder of the exact location and people to which America owes arguably the largest debt of gratitude, in terms of how we rose to greatness. Black history in America largely stems from the transatlantic slave trade, and without the African architects, builders, inventors, agriculturalists, and many others who built this nation from the ground up, the world today may not know of America as a prominent country. Black history made America great.

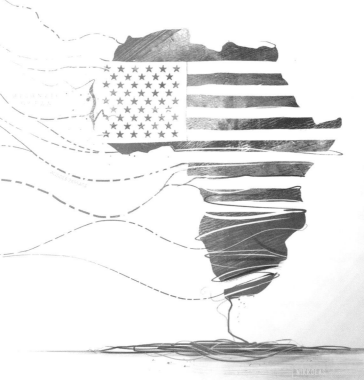

BLACK LIVES MATTER

by Dionna Gary

From a design called "Peace & Whet?" black hands throwing up the peace sign, or could be interpreted as saying "Peace" and physically leaving. What we want and the result of being emotionally drained from society.

Black Lives Matter

MAKES AMERICA GREAT

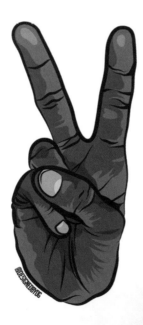

BOURBON & WHISKEY

by James Furious

The only way I know how to deal with tragedy is through humor. So when the question was asked, "What makes America great?" my immediate thought was Kentucky bourbon . . . and A LOT OF IT. It could be a rough four years, but the truth is I don't drink.

BOURBON WHISKEY MAKES AMERICA GREAT

BROTHERHOOD

by James Nesbitt and Thea Leming Brandt

The fabric of our country is woven from many threads in different colors, heritages, religions, beliefs, and orientations. The allegiance to each other and to creating a better country for forthcoming generations are the ties that bind. This is what makes America great. Created on felt with nails, thread, and a helluva lot of dexterity.

CIVIL DISOBEDIENCE

by Michael Czerniawski

We are very fortunate to live in the United States of America. We enjoy so many freedoms that people around the world can only dream of. However, those freedoms were not always available to every citizen. Thankfully, activists across the timeline of our country have stood up for what is right on behalf of us all. This piece is an attempt to depict some of those struggles and how they have become an honored part of our country's history.

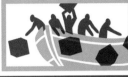

NO
VA
SÍ S
PUE
RAISE
WAGES
RIGH
VO
CIVIL
RIGHTS

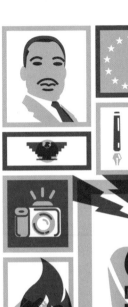

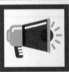
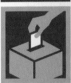
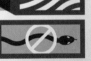

CTIVE
STAT
SSS
CAR
RM 7

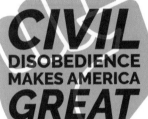

CIVIL
DISOBEDIENCE
MAKES AMERICA
GREAT

MONTGOMER

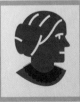

CIVIL SERVICE

by Hayley Gilmore

Inspired by WPA artwork, I designed a poster based on the importance of civil service in America. A civil servant is a person in the public sector employed for a government department or agency. Some examples of civil services in the United States of America include foreign affairs, personnel management, general accounting and administration, budget administration, legal counsel, passport visa services, public affairs, postal service, contract procurement, and information technology management. According to *Politico* magazine, an estimated two million civil servants help sustain American democracy.

CIVIL SERVICE MAKES
AMERICA
GREAT

COMMUNITY

by Micaela Brody

In the first weeks of 2018, I came to realize that the greatest thing about America is the communities we create and the strength they give their members. Communities create strength from fear. When people amplify each other's voices, speak together, and support each other, all are made greater.

DIVERSITY

by Sawsan Chalabi

Ethnic and racial diversity is what makes America great. What I love about America the most is that one can experience a multitude of different cultures, languages, cuisines, folklore, and traditions all in one place. Here we learn to respect and appreciate one another's differences, and taking all these experiences in makes us richer and better human beings. We must continue to be a beautiful example of harmony and coexistence.

What *Really* Makes America Great

DIVERSITY OF LANGUAGES

by Daisy Patton

The amount of languages spoken by everyone living within our borders makes America great. According to the census, there are at least 350 languages represented. In Los Angeles, my hometown, at least 185 languages are spoken, and as a child it was magical to learn about so many people through their communication. Language is one of the most intimate and complex ways people can be connected; with no official language, America reflects its history, population, and wonderful mix of cultures that make this nation great.

EDUCATION

by David Hays

"Education" was inspired by my insatiable love of books and a passion for the propaganda art form. But more importantly, this poster was created in direct response to the Trump administration's attack on public school systems. Many Trump voters believed he would stand up for working people and create jobs, but they voted to dismantle public education and the promise and potential it offers their children. Trump is not only pick-pocketing teachers and students but also sowing the seeds for the demise of American ingenuity and thought leadership.

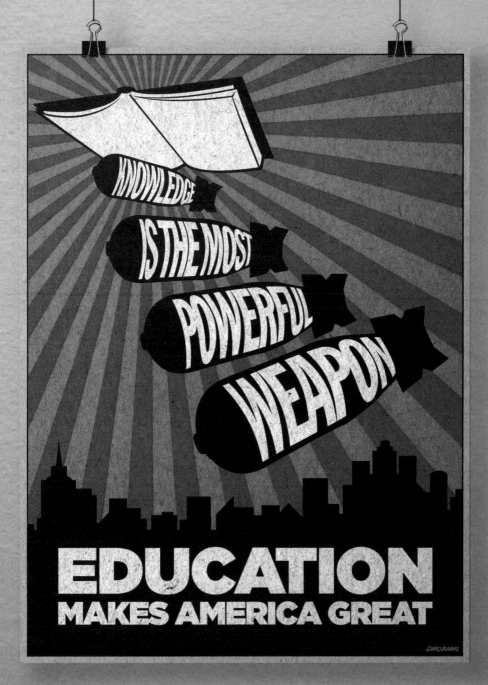

EMPATHY

by Alyssa Winans

I wanted to celebrate empathy, because although many things can't be solved with empathy alone, I believe that trying to understand where someone is coming from and what they are thinking about is a useful start to any productive discussion. In a country as diverse as the United States, empathy has always been a core component, and it always will be.

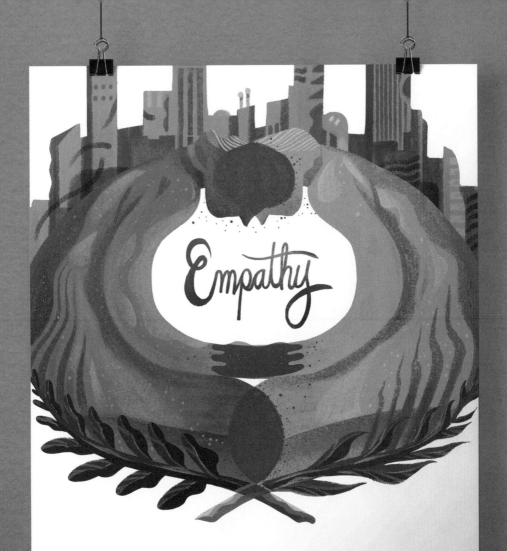

ENERGY INNOVATION

by Samantha Yost

The United States has great potential for renewable energy sources, from the sun-drenched deserts of the Southwest to the windy coasts of New England. Although we have the capacity to power our nation through the sources of renewable energy that are available today, the United States could truly become a world leader by researching and innovating new ways to produce electricity in a clean, environmentally sustainable way.

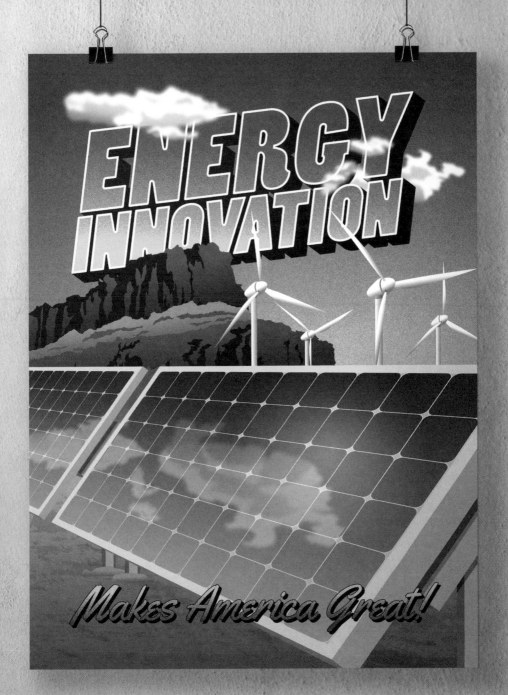

EQUAL OPPORTUNITY

by Lorraine Nam

My story begins in America, where I was born to immigrant parents in search of opportunity. As an American, I am lucky to have more opportunities than my parents had in their home country. While we still have lots of progress to make toward equal opportunity, we live in a country where we will not settle and we will continually strive to do better for all Americans. This is what makes America great.

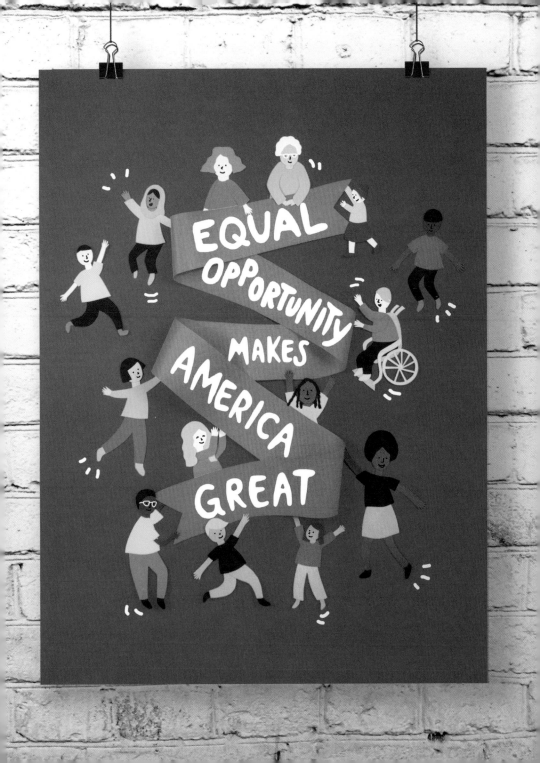

What *Really* Makes America Great

EVERYONE WELCOME

by Crystal Sacca

Our nation is at its best when we celebrate equality and embrace our diversity to welcome folks of every shape, size, color, ethnicity, religion, gender, sexual orientation, and more. In light of the Trump administration's downright un-American policies, I wish we could place one of these flags in every window to let people know they are loved and welcome in this country.

EVERYONE

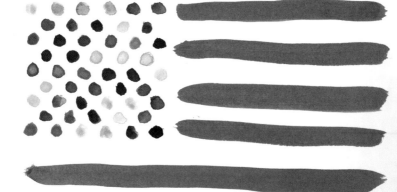

WELCOME

MAKES AMERICA GREAT

FIREFIGHTERS

by Bob Rubin

As fires rage across the landscape, affecting businesses and residential structures, we all marvel at the heroism of America's firefighters. We give thanks and gratitude to these brave men and women who risk their lives, every day, for all of us at home or work.

FIREFIGHTERS

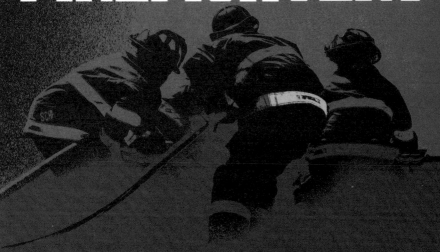

Make America Great

FREEDOM OF CHOICE

by Jason Roache

America is great because of our individual freedoms, including the choice of peace, protest, or resistance. We are free to choose what we will accept and tolerate as a nation and express it in powerful ways.

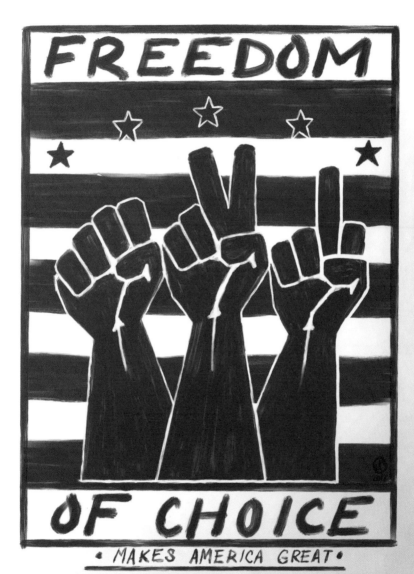

FREEDOM OF SPEECH

by Andrew Martin

The feeling of being behind a microphone conjures up a lot of intense emotions. Anxiety, fear, excitement, joy . . . The reason we feel these things is because we know that as Americans, we're given the incredible agency to say what we truly believe. That's a powerful right and a weighty responsibility. With my design, I wanted to put the audience in that hot seat. I wanted to remind them that America is great because we have the innate ability to change it from behind a microphone.

FREEDOM OF THE PRESS

by Elena Ospina

Freedom of the press and freedom of expression make countries great. Freedom of the press is necessary in any solid democracy. Without freedom, democracy is not possible. The United States has stood out for defending this right to free expression. But the rights must always be defended because they can be lost. When the freedoms of thought are threatened, the development of societies is also at risk.

FREEDOM OF THE PRESS

by Isaiah King

We're at a time in history when not only is press freedom threatened but so is the very concept of truth. Defending a free press is—of course—important to our democracy. However, a free press is meaningless without a shared belief in the importance of truth and the value of professional journalism conducted with ethical rigor.

freedom of the press
makes America great

GARDENING

by Anna Hartwig

From growing your own herbs to planting a tree, gardening is a wonderful way to relax and be productive at the same time. Whose heart wouldn't grow a little bit bigger seeing a blooming flower?

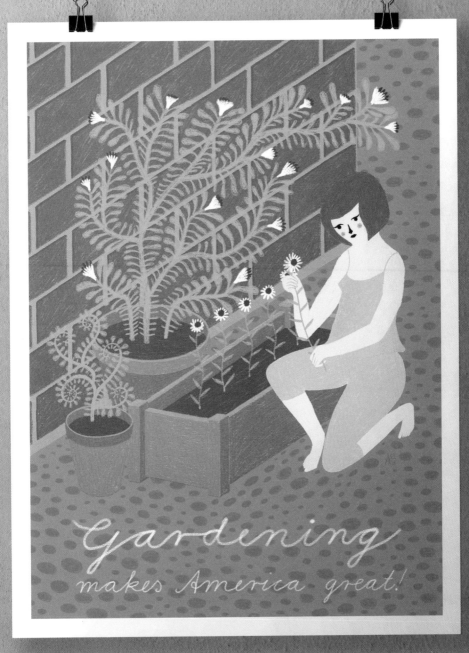

GIRLS WHO RULE

by Lydia Hess

I have been especially inspired by the incredible young women who have stood up for human rights and women's rights these past few months— particularly in regard to the Parkland shootings. This image is in their honor but also just 'cause it's true.

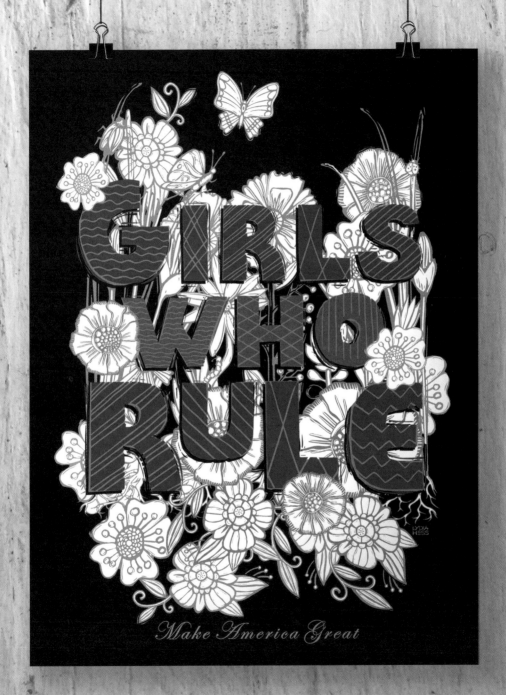

What *Really* Makes America Great

GRACE

by Sharon McPeake

My illustration was inspired by an article in the Atlantic by Victor Tan Chen ("The Spiritual Crisis of the Modern Economy") stating, "[Grace] is about refusing to divide the world into camps of deserving and undeserving, as those on both the right and left are wont to do." This resonated with my belief in the role of empathy in connecting us to the concerns and actions of our cultural and political counterparts. The poster depicts the beauty that spreads when hearts are full of wonder and support for those around them.

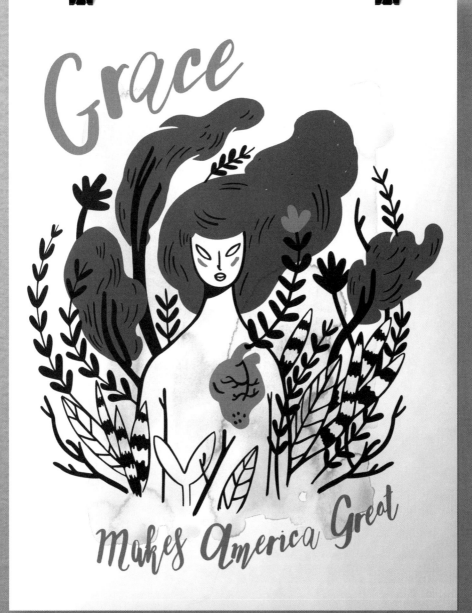

GUITARS

by Holly Savas

This design is based on a collage made from paint, paper, and dozens of music festival programs, gathered over decades across the United States, originally made as a gift to my guitar-aficionado husband. Whether you prefer acoustic or electric, or live in a red state or blue—maybe the bottom line is making music together. That's what makes America really great!

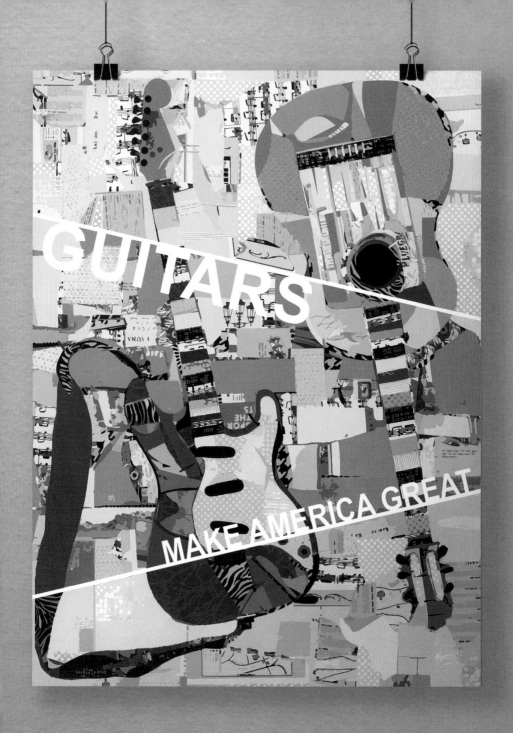

What *Really* Makes America Great

HIP HOP

by Darrell Stevens

Although hip hop culture has spread to every corner of the globe, its birth took place right here in America during the 1970s. A combination of music, dance, art, and poetry, its roots and inspirations can be traced back many decades earlier. With art and culture now under threat like never before, it is important to protect the freedom of expression and creativity that gave rise to this and many other art forms, in the past, in the present, and in the future.

What *Really* Makes America Great

HOLLYWOOD

by Roberto Lanznaster

Because movies can make us feel and think. They are like a mirror, a collective dream.

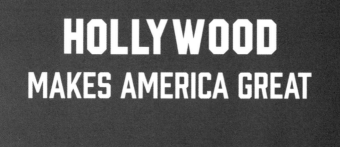

HOLLYWOOD
MAKES AMERICA GREAT

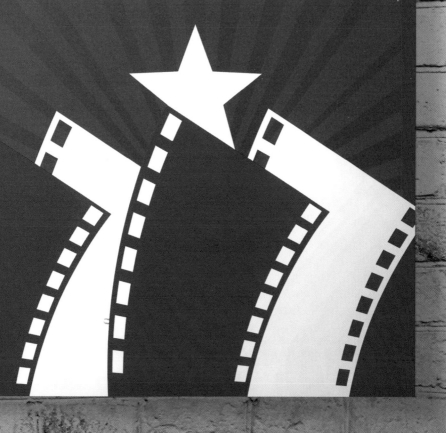

I AM FREE TO BE ME

by Shelley Wright

There isn't just one thing that makes America great. It is not just a type of person, a place to live, or one lifestyle. The greatest thing about America is that we all have the freedom to be ourselves, wherever we are, whoever we are, and however we choose to live. Our founding fathers ensured these freedoms through the Constitution and the Bill of Rights. Yet while these foundational documents continue to be under repeated attack, we resist and forge ahead to all be great.

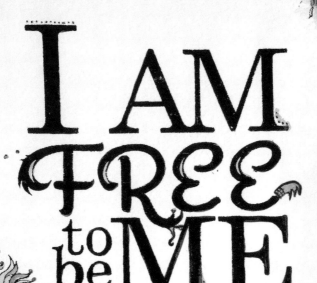

I AM FREE to be ME

that's what

Makes America Great

What *Really* Makes America Great

IMMIGRATION

by Gabriel Benderski

The United States is a nation of immigrants and therefore for immigrants.

IMMIGRATION MAKES AMERICA GREAT

IMMIGRATION

by Chris Lozos

The journey to America, through economic hardship and social injustice, was taken by all of our ancestors. Those who came here had the spirit to overcome great obstacles and the ambition to fulfill their dreams in a new world. Without this steady stream of pioneers, we would not be the proud nation we are today. How would you have wanted your grandparents to be treated when arriving here? Imagine the plight of current immigrants to our shores and the promise of Lady Liberty.

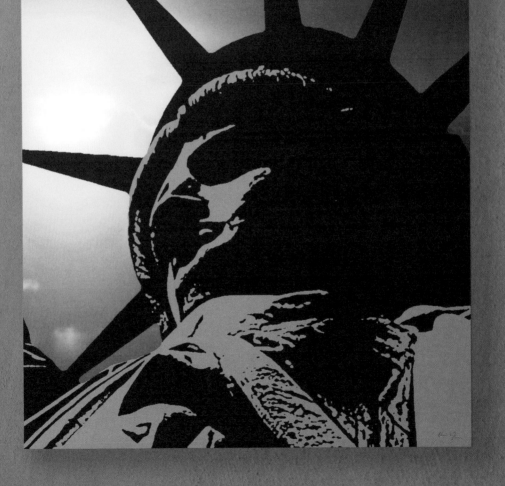

What *Really* Makes America Great

IMMIGRATION

by Yadesa Bojia

The greatness of America is found in the tapestry of people who immigrated from all over the world to create a more perfect union. When we ban immigration, we hinder the flow of ideas and different cultures and affect the brand of America being a hub of people who seek justice and opportunity. Let's stand up for immigration and make America great!

What *Really* Makes America Great

INNOVATION

by Shane Henderson

What makes America great? For one thing, our innovation! Since our nation's founding, some of the most innovative and inventive minds have been born and raised right here in the United States. I wanted my illustration to showcase Henry Ford's Model T, which revolutionized the American auto industry.

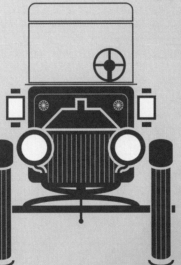

WHAT MAKES
AMERICA GREAT?

INNOVATION

1908
FORD MODEL T

SH.17

INTERSECTIONAL FEMINISM

by Emily Vriesman

Feminism should be intersectional or nothing at all. We must fight for women of all races, all experiences, all sexual orientations, and all backgrounds. Trump wants to keep women silent. We must rise up as women against his divisive rhetoric.

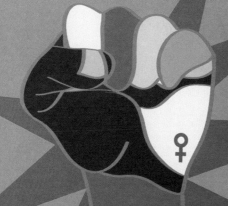

What *Really* Makes America Great

JAZZ

by Aaron Perry-Zucker

"Jazz music is America's past and its potential, summed up and sanctified and accessible to anybody who learns to listen to, feel, and understand it. The music can connect us to our earlier selves and to our better selves-to-come. It can remind us of where we fit on the time line of human achievement, an ultimate value of art." —Wynton Marsalis

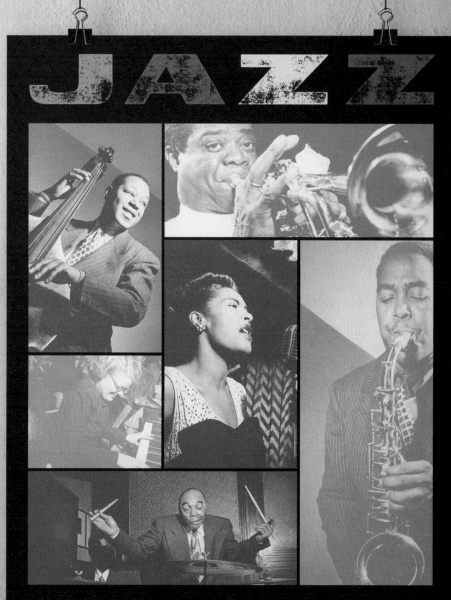

What *Really* Makes America Great

JOURNALISM

by Carolyn Pavelkis

I wanted this poster to speak to the importance of the First Amendment and freedom of the press by calling attention to the work that professional journalists do every day, even while under fire, providing a necessary check/balance in our complex society. Visually, I composited the front pages of newspapers from the 2016–17 election year as a background, then used a silhouette of the Statue of Liberty to represent freedom. The typography is positioned to represent a newspaper nameplate, further reinforcing the overall concept.

JOURNALISM
MAKES AMERICA GREAT

JUSTICE

by Brixton Doyle

Justice is usually depicted holding a balanced scale, symbolizing that both the lowly and the exalted will be treated equally in the pursuit of fair play. There's more to her. She is blindfolded, not blind: a safeguard against even herself presuming any slight prejudice. Importantly, Justice carries a sword to battle anyone or any interest that would dare undermine her integrity. Our system of justice is not perfect, but if we keep a keen eye on fighting for those who most need our resolve, maybe one day it will be.

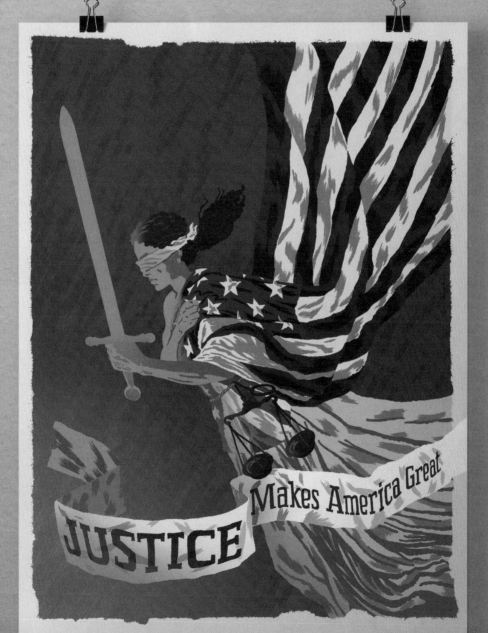

KINDNESS

by Roberlan Borges

Kindness makes America great. Kindness makes us respect our neighbors in a time of walls and hate speech, of intolerance and prejudice. A simple design to remind us to be kind. Simple like that. BE KIND.

LADIES

by Susanne Lamb

Women are continuously underrepresented in media, political office, high-paying jobs, and, thus, history. We must constantly combat objectification, perceived weaknesses, and other unique roadblocks to achieve success in what we do. For this piece, I drew a selection of brave, groundbreaking, high-achieving American women who have shaped history and inspired us all to demand more.

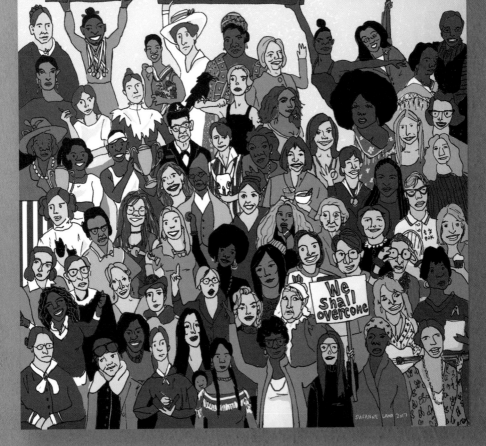

What *Really* Makes America Great

LANDMARKS

by Beth Kerschen

America is a nation that is a celebrated cultural mecca influenced by people from different cultures, art, science, technology, architecture, pop culture, and our amazing natural landscape. In this piece, our culture is represented by American landmarks and icons spanning from coast to coast, including our farms, ranches, mountain towns, suburban areas, national parks, and vibrant cites. This unified whole, from sea to shining sea, is what makes America great. We would not be the same great country without each and every one of them.

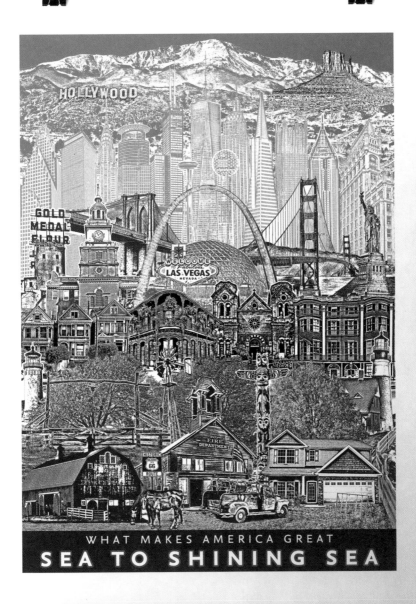

What *Really* Makes America Great

LATINAS

by Maria Castro

In today's world it is important to remind society that women have a voice but, most importantly, Latinas have a voice. We are here to scream loud and clear, Latinas make America great.

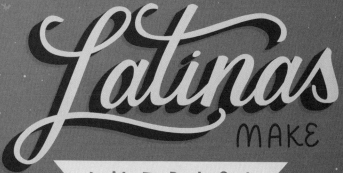

LOVE AND COMPASSION

by Vikram Nongmaithem

The United States has been known to everyone for many reasons. One such reason is the people's love toward humanity and treating all the same, with love and compassion. As I come from a multicultural, multireligion, and multilingual place like India, I strongly feel love and compassion are what bring people together and create hope for the nation in the future.

MADRES

by Yocelyn Riojas

"Madre: la palabra más bella pronunciada por el ser humano." —Khalil Gibran
This illustration was created to celebrate the strong, resilient women who raised us, our mothers.

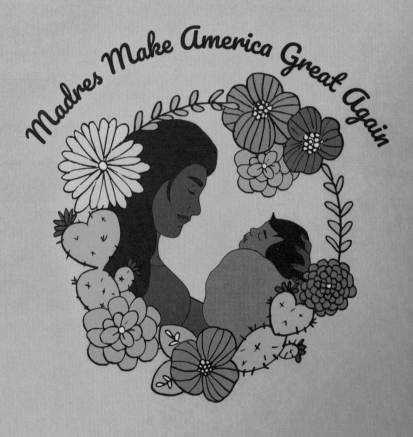

MARRIAGE EQUALITY

by Mark Addison Smith

My partner and I entered into a civil union in 2011. A clerk with red, white, and blue-painted fingernails at Chicago City Hall upgraded our civil union to a marriage in 2015. She stamped our paperwork and declared: "You've now been married four years!" Our history changed in seconds. Following the 2015 Supreme Court ruling granting US marriage equality, then-President Barack Obama proclaimed: "This decision affirms what millions of Americans already believe in their hearts: when all Americans are treated as equal, we are all more free."

MARRIAGE EQUALITY

Makes America Great.

NATIONAL PARKS

by Eric Junker

Our national parks make America great. They are our shared treasure. They are a symbol of a legacy of freedom and a set of collective values that has been gifted to us by previous generations. It is our obligation to preserve this treasure and pass it on, intact, to generations that will follow us. Our national parks connect us with nature. Time in nature reminds us that our physical and spiritual survival is inextricably linked to our relationship with the natural world.

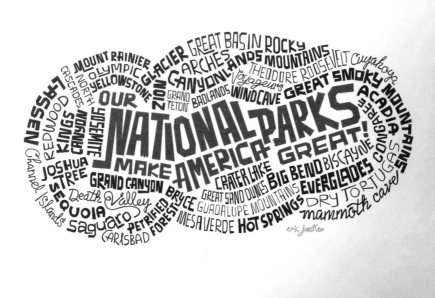

OUR NATIONAL PARKS MAKE AMERICA GREAT!

MOUNT RAINIER · OLYMPIC · NORTH CASCADES · LASSEN · REDWOOD · KINGS CANYON · YOSEMITE · GLACIER · GREAT BASIN · ROCKY MOUNTAINS · ARCHES · CANYONLANDS · ZION · GRAND TETON · BADLANDS · THEODORE ROOSEVELT · Cuyahoga · Voyageurs · WIND CAVE · GREAT SMOKY MOUNTAINS · ACADIA · CONGAREE · JOSHUA TREE · Channel Islands · SEQUOIA · Death Valley · GRAND CANYON · BRYCE · CRATER LAKE · GREAT SAND DUNES · BIG BEND · BISCAYNE · EVERGLADES · DRY TORTUGAS · Saguaro · PETRIFIED FOREST · GUADALUPE MOUNTAINS · MESA VERDE · HOT SPRINGS · mammoth cave · CARLSBAD

eric jinkles

NATIVE AMERICAN CULTURE

by Patricia Weston

Native American culture is woven into the fabric of America. Indigenous people are members of their own sovereign nations and, since 1924, citizens of the United States. Denial of human rights, exploitation, and discrimination have occurred since pre-Revolutionary colonial time, most notably in religion and cultural expression. In spite of the oppression and colonization, Native people are still here. They represent 573 tribes and are stewards of the earth and participants in what makes America great.

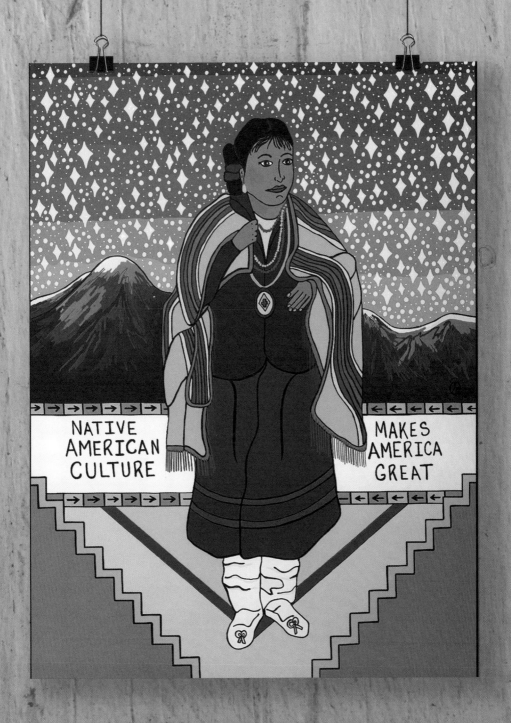

NON-BINARY GENDER

by Ethan Parker

Thinking outside of the box has always pushed progress forward in America, especially breaking out of the gender binary for self-empowerment. This poster features triangles in the colors of the non-binary gender flag.

Non-binary
gender

ethan
parker
2017

makes America great

What *Really* Makes America Great

OPINIONS

by Robert Wallman

What's my opinion? What's yours? Theirs? Ours? Hers? His? What's the difference? Talk to the hands.

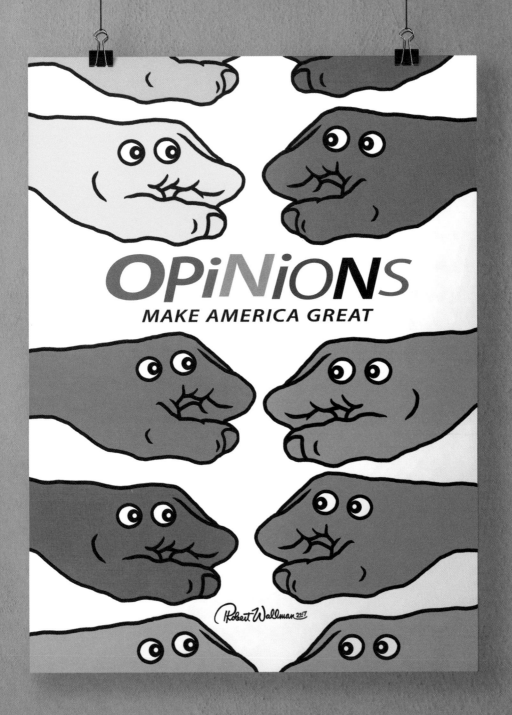

What *Really* Makes America Great

PARKS

by Jessica Gerlach

I enjoy our city parks. Former US Secretary of the Interior Bruce Babbitt said, "City parks serve, day in and day out, as the primary green spaces for the majority of Americans." I believe these green spaces are just one more thing that makes America great.

PEOPLE WITH KIND HEARTS

by Caitlin Alexander

I often have to remind myself of the beautiful, loving souls in my life and how these speckles of light in the dark sky are really what make life worth living. I've found that just when I think there are only monsters in this world, I'll be the recipient of a random act of kindness or touched by the generous spirit of a friend. Yes, we all have enemies, but we can't forget to appreciate our allies—and what wonderful parts of life they share with us.

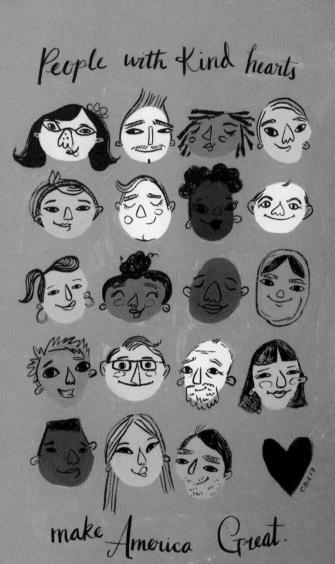

What *Really* Makes America Great

PROTEST

by Karl Orozco

I am interested in how narratives written by those in power dominate our universal head canon. The imperialist, the colonizer, and the capitalist find ways of claiming space, time, and narrative, too. My work tells stories that challenge assumed notions of race, family, immigration, and power. As a Filipino-American artist, I wish to thread the experiences of the Filipino diaspora and use these connections to understand broader social conditions.

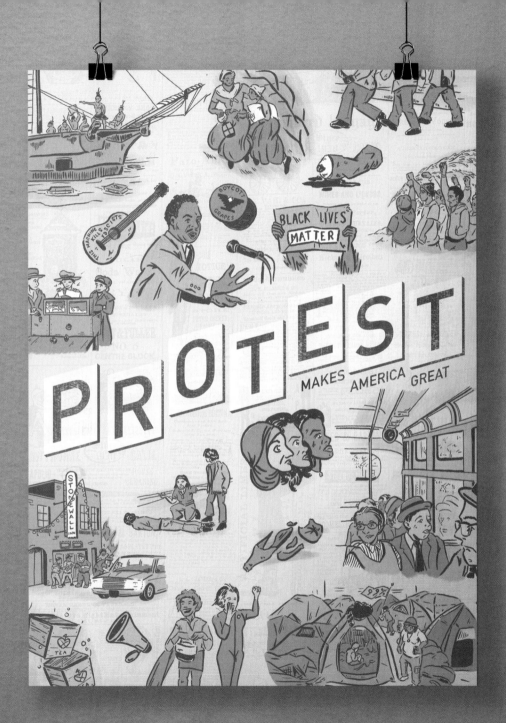

What *Really* Makes America Great

PUBLIC LANDS

by Amanda Lenz

Public lands are national jewels, an open door to wildlife, nature, and exploration. Let's keep them pristine.

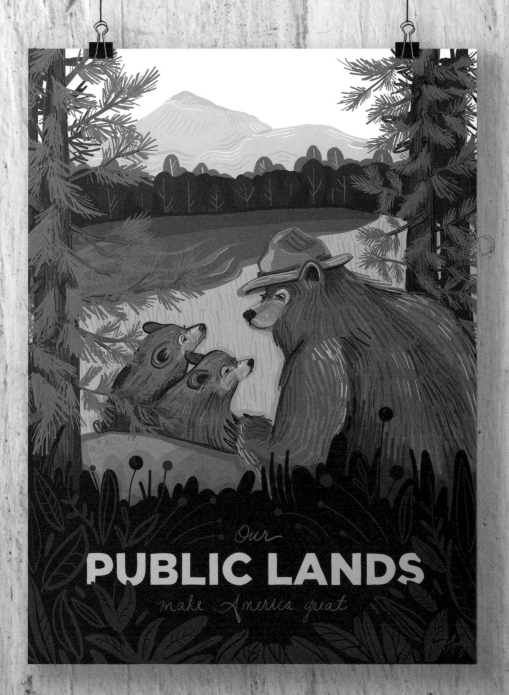

PUBLIC LANDS

by Todd Gilloon

Right now, special interest groups and their political allies are running an aggressive campaign to sell off large portions of public lands in the west. They want to see our national lands privatized for short-term gain. Public lands make America great, and they belong to EVERYONE. Please help protect our public lands!

PUBLIC LIBRARIES

by Daria Theodora

Libraries, for me personally, are a sanctuary, a calm place where I can sit in a corner and be immersed in a book or two and, in some, be in awe of the building architecture that houses them. Public libraries, though, do not only serve readers like me. They provide an oasis of knowledge and an abundance of fantasy and aspiration to anyone without discrimination. They provide a safe place for the community to gather and exchange ideas and to educate the next generation.

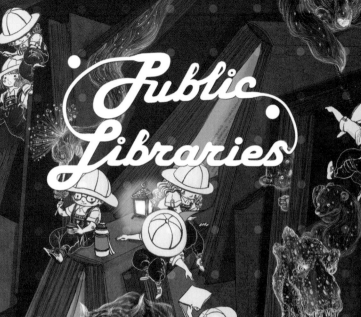

QUEER IDENTITIES

by Kyle Parker

In a time when queer rights are under attack, it's important to unify with other people within the LGBTQ+ community.

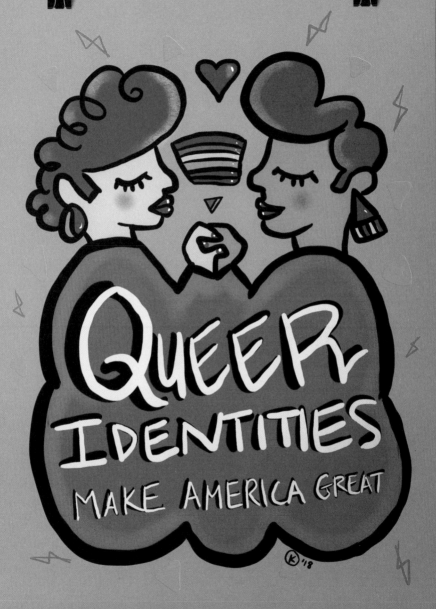

RELIGIOUS FREEDOM

by Mark Forton

This image celebrates the American spirit—that all people are able to worship as they feel compelled versus being limited or threatened by a government for their beliefs. The freedom to worship God in his/her own way is a fundamental human right.

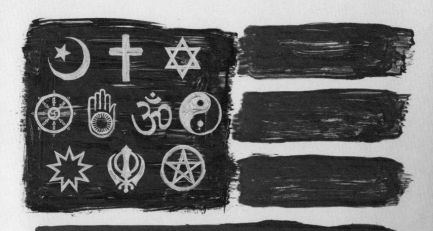

RELIGIOUS
FREEDOM
MAKES AMERICA GREAT

RENEWABLE ENERGY

by Liz Cook

Wind turbines have always filled me with a sense of wonder. As the harvesting and consumption of energy continue to impact climate, environment, and communities, these towering structures along with other renewable energy sources stand filled with possibility for the future.

RESILIENCE

by Emily Kelley

When times get hard, we persevere. Like water, we let it roll off our backs. Our resilience is what makes us come back stronger than ever, it's what makes us keep going, and it's what will keep us from never giving up. This poster was created to highlight the word "resilience" in a way that made it feel like water on paper, or a material that was elastic.

RE · SIL · IENCE

MAKES AMERICA GREAT.

RESISTANCE

by Trevor Messersmith

I started making resistance posters in the wake of the 2016 election. Americans can never take any freedoms for granted. Being able to openly resist oppression and challenge authority are what make America great.

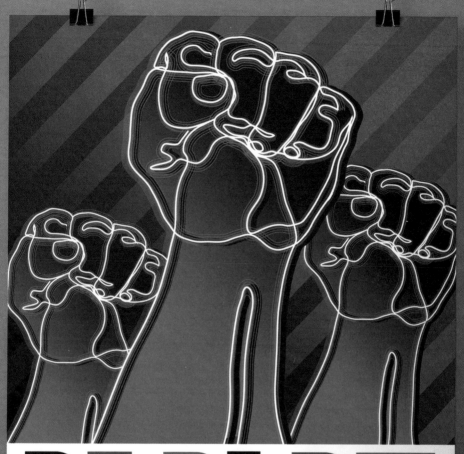

RESISTANCE

MAKES AMERICA GREAT

SACRED, PROTECTED NATURE

by Vanessa Koch

The natural landscape of America is a treasure and a birthright of all Americans. Preserving our sacred lands and waters is our collective duty. Generations of Americans should continue to experience the wonders of the American landscape. "America the Beautiful" speaks of purple mountain majesties and amber waves of grain, ending with the unifying "crown thy good with brotherhood [and sisterhood] from sea to shining sea!"

FROM

SEA

TO

SHINING

SEA

SACRED, PROTECTED NATURE MAKES AMERICA GREAT

What *Really* Makes America Great

SCIENTIFIC EVIDENCE

by Michelle Martir

Our country works best when we have scientifically proven results and evidence, free from ignorance. By working with nature's rules instead of against them, America will become a stronger, healthier ally of the pale blue dot we call home.

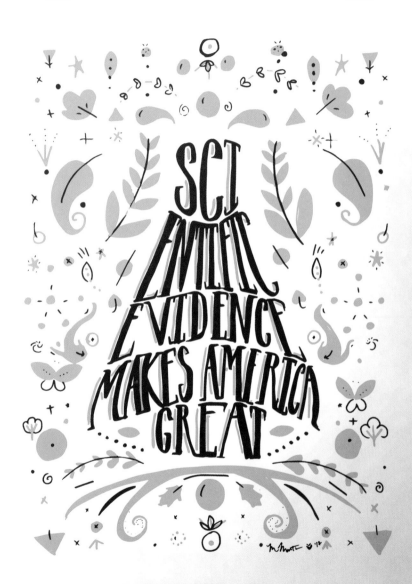

SMALL BUSINESSES

by Jonathan Garbett

Working for a small business has been greatly rewarding. I feel that the "mom-and-pop" shops need to make a comeback. This poster is made to give the viewer an urge to shop small.

SPACE EXPLORATION

by Design By Goats

Exploring beyond earth: what an awesome endeavor! We learn not only about the makeup of the universe but also about ourselves as a species and spark the imaginations and excitement of children and adults alike. I am proud to live in a nation that leads the way in space exploration and that allies with others in the name of science, exploration, and the advancement of humanity—advancements we may someday rely on.

SPACE EXPLORATION
MAKES AMERICA GREAT

TACO TRUCKS

by Catherine Nguyen

In 2016, a Mexican-American Trump surrogate said, "If you don't do something about [my culture], you're going to have taco trucks [on] every corner." So first of all, that sounds awesome. But I'm also sad that an American felt this way about his culture. Besides, American culture is immigrant culture. Imagine American cuisine without Italian or German immigrants (no pizza, no hot dogs). What's now all-American was once "too ethnic." So let's continue the evolution! Embrace your food and savor how great America already is.

TACO TRUCKS

MAKE

AMERICA

GREAT

TEACHERS

by Monica Loos

Apples and teachers are the quintessential pair. I could not be a bigger believer in the importance of education. A solid, widespread, deep education for ALL. Teachers are everything. A good teacher is a treasure, and I wanted to honor that. My submission features a watercolor on paper.

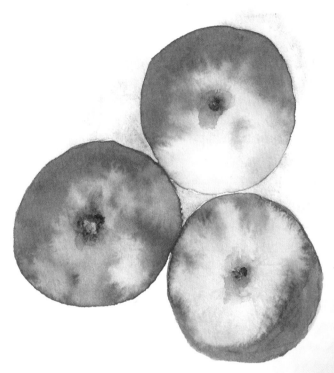

TEACHERS

make America great!

TENACITY

by Danielle Deley and Ellen McDevitt-Stredney

America was built on questioning authority and systems of oppression. Even in modern times, the moment we back down, accept mediocracy, or contently live under hateful tyranny is the moment we've settled. It's not only that we all deserve better but also that we can all do better. Let's work to make that happen. Tenacity is what makes America great.

AMERICA WAS
BUILT BY UNDERDOGS.
WHEN WE'RE TOLD
TO SIT,
WE DON'T.
NO MATTER THE SIZE
OF THE FIGHT,
WE DON'T SHY AWAY.
WE GRIT OUR TEETH,
AND BITE DOWN.
TENACITY MAKES
AMERICA GREAT.

THE BELIEF THAT ANYTHING IS POSSIBLE

by Adam Doyle

My work always begins with a love for the magic of creation—the blank surface transformed into a living thing or another world. This act has been with mankind since the first paintings on cave walls yet never ceases to be awe-inspiring. I always want my marks to be visible, to keep this sense of wonder present. I'm committed to making images that speak truth to power, that provide space to breathe, and that use simple forms to reveal and make accessible the heart of stories.

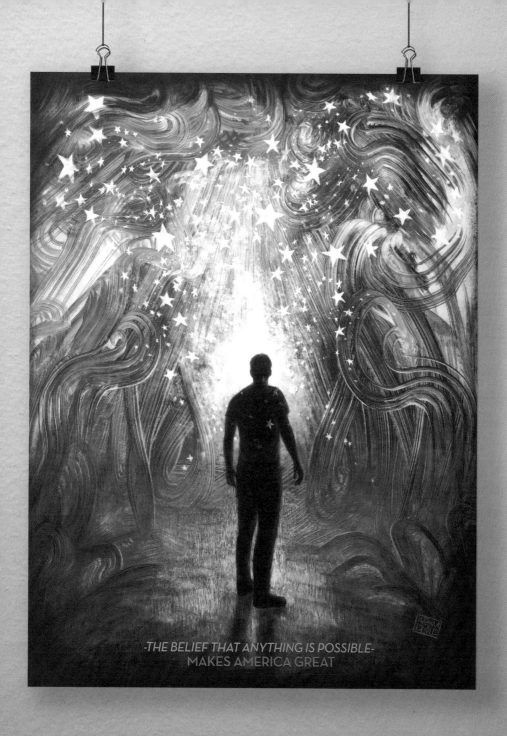

-THE BELIEF THAT ANYTHING IS POSSIBLE-
MAKES AMERICA GREAT

THE RIGHT TO PEACEFUL ASSEMBLY

by Kevin McGeen

The ability for people to peacefully express their views, and not fear violence or threats for that expression, is fundamental to democracy. It is through people coming together, voicing concerns and beliefs, that change has been affected.

THE RIGHT TO PEACEFUL ASSEMBLY
MAKES AMERICA GREAT

THE UNITED FACES OF AMERICA

by Aditi Raychoudhury

I am an immigrant. As my husband, little daughter, and I took our first steps in our very first march in this country, I saw that I was surrounded by an ocean of diverse ethnicities, religious beliefs, sexual orientations, genders, and abilities who were bound together by the common belief that every human is free and equal in dignity and rights. I felt deep pride and gratitude realizing that this immigrant family belonged amid the United Faces of America who come together again and again to make this country great.

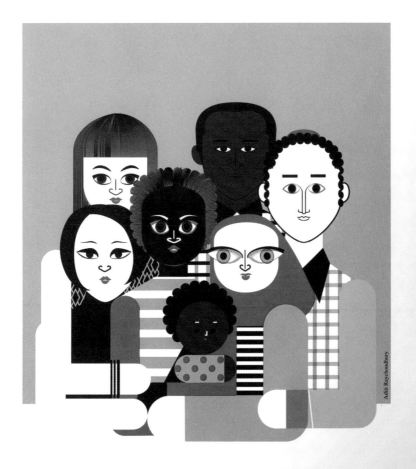

THE UNITED FACES OF AMERICA

MAKE AMERICA GREAT

Aditi Roychoudhury

UNITY

by Jillian Marsala

What started off as a last-minute iPad sketch for a Swiffer protest sign quickly became something much, much more. On January 21, 2017, over 3 million women and allies marched across the country to make our voices heard and to support women's rights and civil liberties. I marched in solidarity alongside all of my fellow "nasty women" while proudly hoisting my "Unite" protest sign in the air in honor of women everywhere because unity makes America great. Ladies, UNITE!

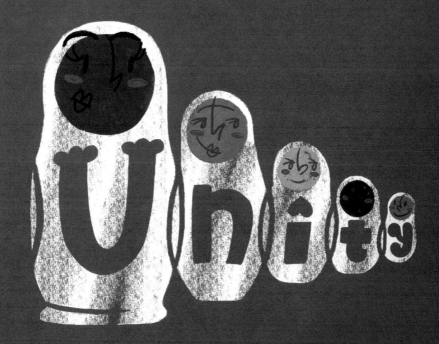

MAKES AMERICA GREAT!

What *Really* Makes America Great

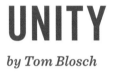

by Tom Blosch

Being around great people in stunning scenery makes the world a pretty great place. With the current climate of our world, I wanted to remind people that we're all basically the same: human beings. Unity is vastly more important than anything at this time. Unite!

VETERANS

by Marie Murphy

I've never been much of an army person, as I never grew up around them, but I do realize that they put their lives at risk to defend us. Living in San Francisco and seeing so many veterans who have become homeless makes me so sad. I am grateful to them for all they have done and endured and keep enduring.

Thank You!

VETERANS
MAKE AMERICA GREAT

What *Really* Makes America Great

WE ALL

by Taryn Hann

Our cultural diversity, our acceptance and love for all types of people, and the right to free speech are some of the greatest things that America has to offer. This project is made with a combination of photography from a sister march of the Women's March and typography. These photos showcase diversity, our right to protest, and our beliefs with the sharp contrast of bold and strong typography. We all are what makes this country great: The people and what we do with our rights make America great.

WE ALL
MAKE AMERICA
GREAT

HEAR·OUR·VOICE

CHOOSE LOVE
NO HUMAN BEING IS ILLEGAL

WE THE PEOPLE

by Nik Dodani

"We the People" originally meant "We the Landowning White Men." It doesn't anymore. Original photo by Milhem Images Inc.

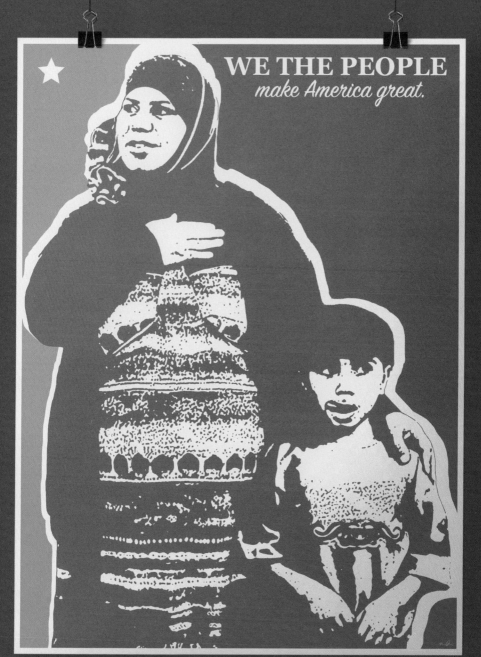

WELCOMING ALL PEOPLE

by Design By Goats

"... the idea of our nation being receptive to all people, welcoming all people ... that in our nation we are many and yet we are one." Words from an interview with the living legend Ruth Bader Ginsburg, who insisted that our country must be more mindful about what makes it great. Her words echoed the thoughts in the poem "The New Colossus" by Emma Lazarus, as seen on the Statue of Liberty, the most prominent symbol of America's welcoming spirit and growth through immigration.

Not like the brazen giant of Greek fame,
With conquering limbs astride from land to land;
Here at our sea-washed, sunset gates shall stand
A mighty woman with torch whose flame
Is the imprisoned lightning, and her name
Mother of Exiles. From her beacon hand
Glows world-wide welcome; her mild eyes command
the air-bridged harbor that twin cities frame.

"Keep ancient lands, your storied pomp!" cries she
With silent lips. "Give me your tired, your poor,
Your huddled masses yearning to breathe free,
The wretched refuse of your teeming shore.
Send these, the homeless, tempest tost to me,
I lift my lamp beside the golden door!"

· THE NEW COLOSSUS BY EMMA LAZARUS ·

Welcoming all people

makes America great

What *Really* Makes America Great

WOMEN

by Darren Krische

When Senate Majority Leader Mitch McConnell responded to the silencing of Senator Elizabeth Warren on the Senate floor in 2017, he unintentionally spoke the words that will be used as a rallying cry for women in this county for decades to come. As a father of a little girl, I know that she, and many like her, will continue to make America great. May they never stay silent and always persist.

ARTIST BIOGRAPHIES

Caitlin Alexander (*People with Kind Hearts*)

Caitlin is an illustrator based in Austin with a particular love for dry-brush gouache painting. Both her life and work are heavily influenced by midcentury aesthetics. Her work focuses on a representation of repeat patterns and texture in our natural world, along with the anthropomorphism of animal characters and messages of strength and acceptance, via hand-lettered typography.

Elizabeth Beals (*Art*)

Elizabeth is an illustrator based out of Atlanta. Her work heavily emphasizes movement and composition while usually focusing on the feminine, geeky, and girly.

Gabriel Benderski (*Immigration*)

Gabriel is an independent graphic designer with a great interest in typography. When it comes to design, he enjoys integrating his concepts with an intelligent use of written language. He values simplicity achieved by the sensitivity of transmitting an interesting visual synthesis.

Jennifer Bloomer (*Belief in the Possibilities*)

Jennifer has identified as an artist as long as she can remember. It is her voice, calling, and a way to digest all that takes place in the world. She has taught art classes and workshops to folks of all ages and backgrounds all around the world. She believes creativity is an essential part of the human experience and lives and works in San Francisco with her husband and two young children.

Tom Blosch (*Unity*)

Tom is an illustrator, painter, and craftsman. "Trying to create on a daily basis" is his mantra. Working as a graphic designer gives Tom the opportunity to bring his ideas to life. Being outdoors is a passion of his, be it camping/hiking/skateboarding/traveling/etc. Experiencing new people and places is where he wants to be, always trying to reach the horizon and see all points between.

Yadesa Bojia (*Immigration*)

Yadesa was born in Ethiopia and immigrated to the United States in 1995. He studied art at Seattle Pacific University. In 2010, Yadesa won a worldwide competition to design the flag of the African Union. Yadesa Bojia lives in Shoreline, Washington, with his wife, Hewan Gebremichael; daughter, Becca; and son, Isaiah.

Roberlan Borges (*Kindness*)

Roberlan is a digital artist and illustrator from Brazil, living with his wife and three daughters in a sunny and warm city called Vitoria. He likes old movies and good music. And coffee.

Thea Leming Brandt (*Brotherhood*)

Thea loves solid design, art, and creating things that make sense and delight! She currently resides in Seattle, focusing on digital experiences and photography.

Micaela Brody (*Community*)

Micaela is a graphic designer living and working in Boston, primarily focused on print. A designer since high school and a graduate from Boston University's College of Fine Arts, she has developed a fascination with kitsch, lo-fi design, and the concept of the middlebrow. Micaela draws eyes incessantly and can usually be found with a coffee in hand and her nose in a book.

Maria Castro (*Latinas*)

Maria is a graphic designer with a great love for letters. Born and raised in Mexico but currently living in San Antonio, Maria has a passion for lettering and brings her work to life with colorful and vibrant graphics.

Sawsan Chalabi (*Diversity*)

Sawsan is a Lebanese-American illustrator and designer. She earned her MFA in illustration from the Savannah College of Art and Design in Savannah, Georgia. She loves incorporating wit in her work.

Liz Cook (*Renewable Energy*)

Liz is an artist, musician, and non-profit professional based in Boston.

Michael Czerniawski (*Civil Disobedience*)

Michael is an educator who lives just outside of Chicago. He specializes in enhancing school improvement efforts. He loves illustrating when not helping kids at school or playing with kids at home.

Danielle Deley (*Tenacity*)

Danielle is an artist and graphic designer. She lives in Columbus, Ohio.

Design By Goats (*Space Exploration, Welcoming All People*)

Kailee enjoys designing, dancing, snacking, bossing, snuggling with kitties, being very warm, and consuming mass amounts of chocolate. She wears all the hats at Design By Goats in Portland, Oregon. She prays (to no one in particular) for financial stability and for men to stop interrupting her.

Duke's body lives in Portland, Oregon, while his mind lives somewhere in the clouds above it. He earns his keep as the Grand Emperor of Design By Goats. The last time he cried was

when he watched *Interstellar*. He enjoys rocking out and eating chips and salsa and drinking beer and/or coffee and his favorite word is "and."

Nik Dodani (*We the People*)

Nik is an actor and comedian in Los Angeles best known for his roles in the revival of Murphy Brown and Netflix's autism dramedy *Atypical*.

Adam Doyle (*The Belief That Anything Is Possible*)

Adam is a career exhibiting artist and published illustrator. He earned his bachelor's at Rhode Island School of Design and later his master's at School of Visual Arts. Adam has lived for a time in Rome, Los Angeles, New York City, Auckland, and Hong Kong. He currently resides in Boston.

Brixton Doyle (*Justice*)

Brixton is a designer, illustrator, and teacher based in New York.

Mark Forton (*Religious Freedom*)

mafMOVE (MAF and MAFmovement©) is the moniker of successful contemporary mixed media artist/graphic designer Mark A. Forton, based in beautiful Michigan. Mark's work has been seen in publications and galleries around the world.

James Furious (*Bourbon & Whiskey*)

Feeling generally frustrated by the injustice of everyday life, James vents his considerable anger through art and design.

Jonathan Garbett (*Small Businesses*)

Jonathan is a graphic designer based out of Brighton, Colorado. He graduated from Colorado State University in 2017. He's continuing to learn more technique now that he's out of school.

Dionna Gary (*Black Lives Matter*)

Femme African American graphic designer/illustrator (artivist) Dionna creates branding/illustration works for start-up black-owned businesses that center black progressive thoughts.

Jessica Gerlach (*Parks*)

Jessica is a designer and illustrator currently living in Portales, New Mexico, where she teaches art and design at Eastern New Mexico University. She is passionate about design, science, letterpress, hand-lettering, books, animation, and beautiful things. In her free time, Jessica enjoys biking to work and hiking in the desert as well as traveling to new places.

Todd Gilloon (*Public Lands*)

Todd is a full-time ER nurse with a passion for art, especially oil painting and photography. What inspires him most is his family, friends, and all things outdoors.

Hayley Gilmore (*Civil Service*)

Hayley is a graphic designer located in Columbus, Mississippi. In 2017, she designed a series of posters for the Women's March, one of which went viral online and featured Carrie Fisher as Princess Leia with the slogan "A Woman's Place Is in the Resistance." That poster is now part of the Library of Congress' archive of American protest art.

Taryn Hann (*We All*)

Taryn is an illustrator, designer, and social media marketer based out of Providence, Rhode Island. As a designer, Taryn values the power of visual storytelling and aims to create memorable, socially relevant, and impactful artwork. She holds more than eight years of experience in the field and hopes to expand her experience and portfolio as she continues as a freelance designer in New England.

Anna Hartwig (*Gardening*)

Anna is an illustrator based in Leeds. She's inspired by mythology, science fiction, and nature. She's represented in the UK by ROAR artist agency.

David Hays (*Education*)

David is a proud tenth-generation Californian, and he's lucky to have teachers, architects, Vaudeville actors (and at least one founding father of early California) nestled in the branches of his family tree. He counts graphic design and illustration as his favorite expressions of creativity. He currently works at Blizzard Entertainment in the Story and Franchise Development team with the world's most talented collaborators making epic, unforgettable entertainment experiences.

Shane Henderson (*Innovation*)

Shane is an artist, graphic designer, photographer, and illustrator from a town just north of Pittsburgh. Along with his father, Don, he owns and operates Henderson Graphic Design & Illustration.

Lydia Hess (*Girls Who Rule*)

Lydia is an illustrator, art director, and graphic designer. In a career spanning three decades, she has worked for magazines, design firms, and publishers as well as her own company. Since 2010 she has been the Senior Art Director/Image Editor and product developer at Amber Lotus Publishing, where she produces 80+ decorative wall calendars, greeting cards, and journals each year, featuring photography, painting, sculpture, and illustration.

Jordan Johnson (*Agriculture*)

Jordan is a freelance illustrator based in Austin. If he's not reading or doing some sort of mad scientist project in the workshop, he's probably drawing airplanes, hot rods, spaceships, skateboarding skeletons, or incredibly cute kittens.

Eric Junker *(National Parks)*

Eric lives in Los Angeles. His murals can be found throughout the United States and as far afield as Mexico and Costa Rica. He currently teaches at USC's Roski School of Art and Design.

Emily Kelley *(Resilience)*

Emily is a graphic design student from Philadelphia. She enjoys the outdoors as much as designing and loves working on projects that benefit the environment in some way.

Beth Kerschen *(Landmarks)*

Beth is photo-illustrator based in Portland, Oregon. She uses a unique photomontage style to create cityscapes that chronicle city culture and history, creating nostalgia for our modern urban environment. Her work is influenced by 25 years of working with photography and graphic design and her love of traveling.

Isaiah King *(Freedom of the Press)*

Isaiah is an artist and designer ruling the world from his headquarters in Greenpoint, Brooklyn. He makes all manner of genius visual communication solutions along with creating woodblock prints, film titles, and animation projects. He is an aspiring amateur boxer and self-ascribed professional IPA and whiskey consumer.

Brandon Kish *(Baseball)*

Brandon is a Michigan-based freelance designer and artist.

Vanessa Koch *(Sacred, Protected Nature)*

Vanessa is an artist and designer. Her process fluidly moves between physical and digital mediums. She lives and works in San Francisco.

Darren Krische *(Women)*

Darren currently lives in Littleton, Colorado. He is a father, a husband, a student, and a freelance graphic designer trying to make the world a better place, one design at a time.

Susanne Lamb *(Ladies)*

Susanne is an artist from Cape Cod, currently living and working in Brooklyn. Her work can be found on books, candles, and pajamas. She can be found drawing, writing, and planning her next vacation.

Roberto Lanznaster *(Hollywood)*

Roberto is a Brazilian graphic designer, illustrator, and writer. Author and illustrator of *The Magic Flute*, a reinvention of the Mozart opera set in the Amazon rainforest; *Imaginarium: Dictionary of*

Monsters; *Imaginarium: Monsters of the New World*; *Pocotinhas* (RHJ); and *The Olympics Chronicles Trilogy: Zeus, Demeter and Athena* (Universo dos Livros).

Amanda Lenz *(Public Lands)*

Amanda is a thoughtful and experienced designer and illustrator living, working, and exploring in colorful Colorado.

Monica Loos *(Teachers)*

Monica is mostly self-taught, and her style is equal parts classic, understated, and whimsical. She is inspired by food, nature, man-made tools, and urban landscapes. Monica works from her home in San Francisco, where she lives with her husband and two boys . . . and one day, a dog, she hopes.

Chris Lozos *(Immigration)*

Chris was born in Pittsburgh in 1944 to a family that had emigrated from Greece in 1912. He graduated CMU in graphic design, served in Vietnam, attended graduate school in visual communication, and worked in graphic design and typeface design. He now lives in Falls Church, Virginia.

Jillian Marsala *(Unity)*

Jillian is an illustrating freelance graphic designer and kid at heart from Chicago.

Andrew Martin *(Freedom of Speech)*

Andrew is a graphic designer and writer living in Los Angeles. He grew up in Delphi, Indiana, and graduated from Purdue University in 2014. He currently works as a graphic designer for Universal Studios Hollywood.

Michelle Martir *(Scientific Evidence)*

Michelle is a designer, developer, and illustrator based out of the Baltimore/DC metro area. She currently works as a UX Engineer for Fractured Atlas, a nonprofit tech company that works with artists. Past employers and clients include Groupon, TeamPassword, OrderUp, and UMBC.

Ellen McDevitt-Stredney *(Tenacity)*

Ellen is a writer and nasty woman. She lives in Columbus, Ohio.

Kevin Mcgeen *(The Right to Peaceful Assembly)*

Kevin is a painter, illustrator, and graphic designer based in Milwaukee, Wisconsin. A major travel enthusiast, Kevin loves incorporating his experiences into his art. He is an avid cyclist and fan of the outdoors and never misses a chance to relax with his dog, Flea, and cat, Fang.

Sharon McPeake *(Grace)*

Sharon grew up in the southeastern United States, where she received her MFA in illustration at

Savannah College of Art and Design. The current era finds her in Oakland, creating illustration, print patterns, brand designs, and fine art for a wide array of clients in the fashion, editorial, and tech industries. When Sharon isn't creating, she's most likely to be found humming a silly song or teaching dance classes.

Trevor Messersmith (*Resistance*)

Trevor is an award-winning photographer and graphic designer based in New York's Hudson Valley. He is owner/creative director of the firm 80east Design.

Marie Murphy (*Veterans*)

Marie is a freelance graphic designer in San Francisco. She typically works with corporate clients and private schools. Maria feels very comfortable throwing together brochures, logos, and newsletters. This poster project was an amazing "out-of-the-box" experience.

Lorraine Nam (*Equal Opportunity*)

Lorraine is an illustrator with an affinity for paper, based in Brooklyn. She creates worlds out of paper for magazines, online publications, and books. She is currently working on a children's book.

James Nesbitt (*Brotherhood*)

James is an award-winning artist and designer living in Seattle. He focuses on digital experiences and film but also creates visceral, interactive art and hand-crafted goods. His work has been featured in *Graphis*, Seattle Show, *GD USA*, *Print*, Step 100, ADDYs, Taschen, Telly's, Prentice Hall, and several US film festivals.

Catherine Nguyen (*Taco Trucks*)

Catherine is a user experience designer working in the Bay Area. She's a second-generation Vietnamese-American, and her stomach is quite pleased about that. She's passionate about diverse representations of people in media and products. Recently, this evolved into a broader mission: bringing social impact considerations into product innovation.

Vikram Nongmaithem (*Love and Compassion*)

Vikram is an India-based graphic designer and visual artist, working as a freelancer with renowned companies like *Tehelka* magazine (news magazine), *Discover India's Northeast* (travel magazine), and *Magis* (an in-house news magazine of a renowned management institute, XLRI).

Karl Orozco (*Protest*)

Karl is an artist and educator based in Queens, New York. He is a teaching artist at the Queens Museum, where he teaches sequential art, printmaking, and animation. Karl is the 2018 Artist-in-Residence at the Neon Museum in Las Vegas, where he will lead intergenerational printmaking workshops and transform the downtown Vegas gallery into a public art casino.

Elena Ospina (*Freedom of the Press*)

Elena is an illustrator and cartoonist from Colombia. She has worked for years on creating and illustrating editorial projects. She has been awarded several international and national contest prizes and honorable mentions in graphic humor and illustration. Her work has been published in books, newspapers, and magazines, and she is a member of Cartooning for Peace.

Ethan Parker (*Non-binary Gender*)

Ethan is a queer, trans graphic designer creating work for social change in a feminist and anticapitalistic framework in Portland, Oregon.

Kyle Parker (*Queer Identities*)

Kyle focuses much of his art through a queer lens. He is dedicated to building community and starting conversations that affect LGBTQ+ people.

Daisy Patton (*Diversity of Languages*)

Daisy is an artist and freelancer located in Aurora, Colorado. Daisy has lived all across America in such states as California, Oklahoma, Massachusetts, and soon Washington. Her varied work focuses on history, memory, and social mythology, as well as playful illustration.

Carolyn Pavelkis (*Journalism*)

Carolyn is a photographer/designer from Chicago, passionate about coffee, yoga, travel, and local living. Her design style is heavily influenced by both modern and postmodern design, notably, Massimo Vignelli and David Carson. She believes in pushing the envelope, that good design matters, and in the necessity of using one's talents to bolster one's community.

Aaron Perry-Zucker (*Jazz*)

Aaron is a designer, community organizer, entrepreneur, RISD alum, and cofounder of Creative Action Network.

Aditi Raychoudhury (*The United Faces of America*)

Aditi is an architect and building scientist by training but has always loved to draw. She is a self-taught illustrator and is currently working on a picture book.

Yocelyn Riojas (*Madres*)

Yocelyn is a Latinx designer, illustrator, and resistance artist passionate about empowering her community through creating a voice for people of color. Her art depicts themes of Latinx culture, women empowerment, and issues surrounding immigration.

Jason Roache (*Freedom of Choice*)

Jason is a husband, a father, a veteran, and an artist. He lives in Southern California with his beautiful wife and their children, ages 21, 4, 2, and newborn.

Bob Rubin (*Firefighters*)

Bob used to work with graphics and exhibition design clients in the Big Apple, before he and his wife moved upstate to a 1790 farmhouse in Cherry Plain, New York, that was built by a Revolutionary War veteran. Bob now devotes much of his creative time to satisfying the requirements of the surrounding wildlife. They are great clients, he claims; they never complain.

Crystal Sacca (*Everyone Welcome*)

Crystal is a *New York Times* best-selling author, former advertising creative director, designer, investor, artist, activist, and mother of three bold daughters who splits her time between living in a blue state and a red state.

Holly Savas (*Guitars*)

Holly is a mixed-media artist originally from Madison, Wisconsin, although she's lived and worked in San Francisco for the past two decades. She's also lived in Spain, Southern California, and New York City, and shows her work throughout California. Holly considers herself a social activist and recently won the Sustainable Arts Foundation Finalist Award given to working artists with families.

Mark Addison Smith (*Marriage Equality*)

Mark is New York City–based artist. Permanent collections include MoMA Franklin Furnace, Tate Library, Watson Library at the Met, MCA Chicago, Kinsey Institute, and the Leslie-Lohman Museum of Gay + Lesbian Art. His daily archive of overheard-conversation drawings, You Look Like the Right Type, is now in its tenth year.

Nikkolas Smith (*Black History*)

Nikkolas, a native of Houston, Texas, and M. Arch recipient from Hampton University, is an author/illustrator and theme park designer. After hours, Nikkolas also leads in youth mentoring on Saturdays with the kids of Compton/Watts, California, giving digital painting lessons and life skills for success. He lives in Los Angeles.

Darrell Stevens (*Hip Hop*)

Darrell is originally from the south coast of England and moved to the United States in 2006. He has been working professionally as a graphic designer since 1995. Now self-employed, Darrell lives in Buffalo, New York. He brings a love of typography, art, and creative design to all of his work.

Daria Theodora (*Public Libraries*)

Daria is an artist/illustrator living in Boston. She is a gold medalist in the Gallery category in the Illustration West (SILA) and has been featured on SILA and on Spectrum. In her spare time, she enjoys leisurely strolls in the woods, biking, and traveling.

Emily Vriesman (*Intersectional Feminism*)

Emily is an active social justice artist. Her passion is to design and create art that positively impacts our communities, our neighborhoods, our country, and our world. Diversity and representation are two things she is very passionate about. All people (especially kids) deserve to see positive role models around them that look like them, that they can aspire to be like and relate to.

Robert Wallman (*Opinions*)

Robert, based in New York, is known to family, friends, and coworkers as a "really good drawer." He is a graphic designer experienced in advertising, corporate communications, marketing, packaging, and publishing.

Patricia Weston (*Native American Culture*)

Luna3 is an American artist, art educator, and activist whose work focuses on social and cultural themes. Compositions are created in 2D, 3D, or digital media, inspired by contemporary issues. Luna3, whose real name is Patricia Weston, is a graduate of Carnegie Mellon University. She resides in Trent, Pennsylvania.

Alyssa Winans (*Empathy*)

Alyssa is an illustrator based in the SF Bay area. When she's not drawing and painting, she can be found gardening and making ice cream.

Shelley Wright (*I Am Free to Be Me*)

Shelley is a designer and fine artist working in the Chicago metro area. Her experience ranges from exhibition design, publication, and package design to papier-mâché and oil painting. Shelley curates a number of private and public collections and exhibitions of artwork and runs a large and published gallery in the center of downtown Chicago. She chooses to live a life rich with color, texture, and overwhelming optimism.

Julia Yellow (*Freedom and Diversity*)

Julia is a Taiwanese illustrator and designer who currently lives and works in New York. She creates her work digitally and loves to make it with a playful, warm, and witty quality.

Samantha Yost (*Energy Innovation*)

Samantha is a graphic designer and illustrator in New York City whose freelance business Terra Cognita Design Studio works with environmentally conscious nonprofits and businesses. She is also employed as a graphic designer with the American National Standards Institute (ANSI).

ACKNOWLEDGMENTS

A special thank you to Michael, Jean, and the team at Andrews McMeel Universal for making this book happen, and to Van Jones and the team at Dream Corps for making a difference every day. Thank you to everyone who has supported Creative Action Network along the way, especially to Corey Ford and the team at Matter.vc. Thank you to Christina Bang and Holly Savas for their help in realizing this project and this book, and thank you to Steven Heller for the beautiful words. Extra special thanks to the Perry-Zuckers, the Slavkins, Erin McNichol, and Jen Schwartz for their incredible support.

Finally, thank you to all the artists who have submitted work to this, or any, Creative Action Network campaign; your talents and passions are at the heart of everything we do, and none of this would be possible without you.

ABOUT CREATIVE ACTION NETWORK

Creative Action Network (CAN) is a global community of artists and designers making art with purpose. We crowdsource social impact artwork, inviting anyone and everyone to contribute their own meaningful designs. We develop those designs into a range of physical goods, from posters to apparel to home goods, and sell them online and in retailers nationwide, supporting artists and causes with every purchase

Learn more at www.creativeaction.network.

Cofounders Aaron Perry-Zucker and Max Slavkin, friends since preschool, have been building the CAN community since 2008, inspired by a shared admiration for the art projects of the Works Progress Administration and a belief in the power of creative communities.